Sunrises and Sunsets

A Daily Journey of Renewal, Redemption, and Rejoicing

James –
you are such
a dear friend.
Share this with your MOM.
Bill Stephen

William Stephenson, PhD

ISBN 978-1-09805-263-8 (paperback)
ISBN 978-1-09805-264-5 (digital)

Christian Faith Publishing, Inc.
832 Park Avenue
Meadville, PA 16335
www.christianfaithpublishing.com

Printed in the United States of America

Other Books by William Stephenson, PhD

Unspoken Love: Prayer for the Journey
Brentwood Christian Press, 1992

A Gift to Self: Poems and Stories of Recovery, Forgiveness, Healing, and Reconciliation
Upswing Publication, 2015

Conversations: Stories and Poems That Speak to Our Soul
Outskirts Press, 2017

To contact Dr. Stephenson, e-mail stephenson2789@gmail.com

Contents

Listening to My Heart

Introduction

This book of devotions is comprised of four components. The first is a collection of poems and prayers that are dedicated to Beginnings. Each day, we are born into a new day, a new adventure, a fresh start. It is my hope that these prayer poems can be used to help you face the challenge of each new day. I am convinced that if our attitude can be one of beginning again, we can then bring hope to not just ourselves but to all those we will encounter.

The second part of the book has to do with the end of our day. To close our day with an attitude of hope is just as important as beginning our day in the same fashion. The "As I Come to the End of This Day" prayer poems are committed to that spirit. They offer an opportunity to help you take inventory of that day and then, regardless of how your day went, find a way to let it all go. When we can let go of the events in our day, then we are better equipped to begin again.

These particular poems and prayer poems are much more confessional than the ones on Beginnings. Almost psalmic, they reflect a well-lived day that needs to be given its rest so that we are able to attain our own.

The third component of the book, and possibly the most important, is for you, the reader, to begin your own journey with beginnings and endings, sunrises and sunsets. Each day, you have been provided an opportunity to journal personal thoughts about the day. Although you'll find prompts for each day, they are only suggestions. It is my hope you will take some time to write your impressions directly in the book. Or perhaps you could write your own prayer or poem that better expresses the events of your day.

The fourth component are true stories of persons who applied this attitude of beginnings and endings. They are dramatic examples of recovery, healing, and discovering hope again.

I urge you to take just one poem at a time, carry it with you throughout the day, give time for yourself, and journal how it touched your soul, your heart, and your best self. If you are in a recovery program such as a twelve-step group, bring it to the group and share it with others. You may know of someone who comes to mind after you have read this. Feel free to send it to them and wish them well on this new day.

Now when it comes to poetry, I have found that poetry read out loud can be more effective for touching our soul. I urge you to read these poems aloud to yourself or with someone you trust. It may take a few times to discover the inflections in each piece. Nonetheless, I am convinced that silently reading them is less effective. Do yourself a favor. Read these poems out loud. You deserve it. The stories can also be read out loud to others but be prepared for your listener or yourself to be emotionally affected by its telling.

The first poem you will come upon was the inspiration for the rest of the prayer poems on beginnings. You will see an abbreviated form of this poem later in the book. Also, I concluded this book with a poem on endings, and it, too, was the inspiration for the prayer poems on letting go. However, the initial title, *Sunrises and Sunsets*, was inspired by Anthony, the little boy in the first story.

I wish you well on this journey. Set aside your opinions about your writing. Just put pen to paper and leave the judgments of what you write to the ages.

Bill Stephenson

A Prologue Poem: Sunrises

What a morning!

God bids the earth to stir
into life,
and it stirs.
At the sound of God's
voice,
creation awakens and sings.
Wild birds join
spontaneous choirs,
the earth unfurls
flowers to flag my
attention.
A butterfly dances
fearlessly in and
around me.
Not a fragile petal on
the tiniest bloom,
but God has given it
glory!

What a morning!

Let me hear this new
morning,
the Voice that is as
soft as the sun,
and as gentle as the
wind.
Whose strong word is
never broken,
and whose mercy
catches me off guard.

What a morning!

An Early Mist

I pause, and I pray
at the beginning of this day.
Lest I walk through the morning
with eyes not seeing
all its life and loveliness
and a heart with no song.

Reflection
Day 1

What word or phrase had the most meaning for you? Why?

Reaching for Calm

As I come to the end of this day,
my soul longs for rest, renewal, and release from anticipation.

Yet,
I ponder what I will face in the morrow,
and my soul weakens even further into despair.

O God,
I need to let go of this day
with all its regrets and fearfulness,
and reach for the gentle calm of this night.

To be nourished by Your peace,
and feel Your loving embrace
without the burdens of tomorrow.

Reflection
Day 1

How would you describe the way your day began and how your day ended?

Stepping Out in Faith

O Holy Spirit,
breathe into me once more
the hope of a new beginning.

As this day begins,
make me stronger than anything that can happen to me.
That without fear at the beginning,
and without regret at the end,
I may give myself to the unknown venture.

Reflection
Day 2

What word or phrase seemed to grab your attention?

Stepping Out in Faith No. 2

O God,
as I come to the end of this day,
help me not to brood over my failures.

As I come to the end of this day,
resensitize me to Your hope for my life,
so that I am free to believe in what You know I can become.

As I come to the end of this day,
teach me to take the next step in faith,
even though I know not where that step will take me.

Reflection
Day 2

What happened in your day that seemed to reflect this poem?

From the Heart

O God,
as I begin this day,
help me to hear and see
from my heart.

Help me as I begin again
to open my senses
to the wonder of this day.

Let the freshness of it
pull and push me along.
Its intimate loveliness
invade my thinking.

Reflection
Day 3

What are the signs that you are hearing and seeing from your heart and not your mind?

A Whisper in the Night

As I come to the end of this day,
I need a fresh hope.

O Soul,
whisper wild secrets
to me again
of a God
who is my constant companion,
and the one relationship that is not terminal.

It is then
I can rest and be renewed
For another day.

Reflection
Day 3

Take a moment and describe God as a constant companion.
What does it mean for you to have God as a constant companion?

Seeking an Inner Balance

Today, O God,
help me to grow in my commitments.

So they will be too strong
to tolerate injustice in my thinking.

So they will be too honest to
tamper with truth in my loving.

So it will be too hopeful
to be lenient with evil

Today,
help me to have an inner balance

So there will be no malice in me,
nor bitterness or revenge.

May I forever blend forgiveness
with blame that I could cast on others,
always saving the sharpest thrust of conscience
for myself.

Reflection
Day 4

Describe what it is like to be out of balance.
Where does forgiveness play a role in this prayer/poem?

A Test of Wills

As I come to the end of this day,
I am full of much that
clutters and distracts,
stifles and burdens.

As I come to the end of this day,
I need to empty myself of
gnawing dissatisfactions,
anxious beginnings,
nagging resentments,
old scores to settle,
the arrogance of needing to be right.

As I come to the end of this day,
let this sacred time fill me with not only
peace and contentment,
but with hope and confidence,
and a passion to bring my will
into harmony with God's will.

And to rest,
believing that the best
is yet to be.

Reflection
Day 4

What is it that you need to empty from your heart and soul?

Starting Over

As I come to this new day in my life
I know that the theme is to begin again.
To start over.

However,
the older I get,
and the longer I live
I yearn for ways to finish things
I have already started.

There are doors I want to open today.
There are walls I want to climb over today.

Sometimes,
my desire for starting over again is really
a cover-up, a smoke-screen
for difficult decisions
I don't want to make today or next.
I need hope.

As I journey into and through this new
day, I need breakthroughs,
I need innovation.

I don't need critics and cynics.
I need door openers and wall leapers.

And so,
I begin again and I sigh,
I now know that I cannot expect
the strength or resources
I will need today until I first step into
the water.

Reflection
Day 5

Describe what "starting over" means to you?

Lost and Found

When this day ended,
I had lost the joy in my life.
I had lost the hope I had for tomorrow.

I need my soul to kiss me again.
To touch me with tenderness.
To whisper in my heart the claim life has upon me.

This day has come to an end,
but my thoughts reach out with trembling hands
into the vastness before me,
grasping at life's larger meaning.

Reflection
Day 5

Describe the metaphor, "kiss the joy"?
What does that mean for you?

Bonfires

Chapter 1

"Anthony," I asked, "you're going home to New Jersey tomorrow. Is there anything you want to talk about before you leave?"

Anthony was nine and had come to California to partake in a medical trial in the hopes the drugs being used in the trial would successfully correct the cancer that was spreading throughout his body. Accompanying him was his mother, father, and his older sister. But the trials did not work for Anthony, and he would be going home without a cure, and what seemed to his family as if all hope was gone. Suddenly, everything seemed to be an ending, and they dreaded thinking of a new beginning without their son, or her brother.

"When I get home, I want to go to the beach. I know I can't get in the ocean or use my beach board, but I just want to be out there so that I can watch my friends, smell ocean air, and just be a part of the action for as long as I can. Maybe even build a bonfire when the sun goes down. Do you think my parents would let me? I can't walk, but I could be carried or maybe the lifeguards would help with their Jeep. I don't know. I was just thinking."

"Anthony, one way to convince them is to think beyond yourself. Who would you consider inviting to this event? Who would value being a part of this event with you?"

Together we began to make a list of everyone he wanted to invite. More than forty people ended up on his list.

"Now, Anthony, why do you want these particular people?

"I want to thank them for all of their love and support since I got sick. I want to tell them how much they mean to me."

"Remember the song I taught you and your family to use to remind each other of the commitment you have made to each other? You could teach them that song, and then they would be part of that commitment!"

"Yeah, that would be so cool!"

"Sounds like we need another family conference, Anthony. Are you up for that? And you need to prepare yourself if they don't support your idea. Remember, you've been thinking about this, but they haven't. You may have to give them some time to get on board. Are you okay with that?"

"I understand, Dr. Bill, but I'm running out of time."

A long silence lingered between us as we just looked at each other. Tears welled up in both of our eyes, and a long hug followed. A meeting of the family took place soon after. Anthony presented his project after several rehearsals in front of me. They thought it was a great idea with conditions. His fever had to be low-grade. His pain had to be at a manageable level, and there had to be a controlled time of two hours. And the weather had to be user-friendly with low winds. He agreed. Anthony and his family left the next day. Their trip to California had come to an end, but their journey back to New Jersey had a new beginning.

To be continued after Day 10.

On Centering

There have been so many moments
when I felt,
frayed, frazzled, and frightened.

O soul,
as I open myself up to this new day,
help me to know
that all I search for
is already within.
Help me to center,
lay hold,
and claim that gift.

Then,
the rest of the day becomes my prayer.

Reflection
Day 6

Describe what it is within you that you search for?

On Seeking

O God of wonder…
today, I went seeking you beyond the frontiers of thought.

But, alas,
the mysteries of life grow deeper.

O God of wonder…
today, I went seeking you in the heavens
amidst the thunder
and unnerving lightning.

Even at my age,
this is but a child's dream.

O God of wonder…
as this day comes to an end,
lead me to seek you more intensely in my own prayers,
and to look more honestly
at what is in my heart.

Reflection
Day 6

What is it that you hope to find?

From Despair to Hope

O God,
save me from living this new day
in disappointment and frustration,
lest measuring myself
by the mood of the moment
and judging myself
by the poorest I have done,
I give up trying to be better.

Help me to move
from the despair of "if only"
into the hope of "next time,"
and to begin again.

Reflection
Day 7

Today, as you review your day, offset each negative with a positive one.

Loving Oneself

O God,
as I come to the end of this day,
keep me from dwelling on my disappointments and frustrations.

Help me to
not be so critical of myself,
focusing only on my mistakes and failures,
and fearful of what the future may bring.

As this
day comes to an end
I choose to free myself
of the mistakes I have made,
and embrace the hope
that comes with tomorrow's dawn.

Reflection
Day 7

Journal how you often judge yourself. Is there another way?

A New Vision

O Lord,
when people speak of Your love,
so many speak with sadness
in their eyes.

Even when they're laughing,
their eyes seem preparing for hurt, disappointment.

Their eyes seem to say,
"Don't get too excited.
Don't be too joyful about your love.
It's not going to last.
No love ever lasts.
In one way or the other,
Your love will also end."

As this day begins,
stop me from continuously looking into the tomb
and turning away, convinced that Your love, like every other love,
is terminal.

Help my eyes to truly see what my soul,
what my heart, hunger to say.

Reflection
Day 8

If you looked at this new day from your heart, what do you see?

Fear

As I come to the end of a difficult day,
my soul is filled with fear of dying.
I must do what I counsel others to do.
I must take some time now
at the end of this day
to reduce this fear by trusting in the great adventure.
I need to take some time
to find a new joy
for this thread of life that God has granted me.
As I come now to the end of this day,
I must learn to wait in silence
and to trust in the darkness.
It is in these times
when I lose my balance
to remind myself that waiting to catch me
are God's everlasting arms.

Reflection
Day 8

When you are standing in the darkness, what can help?

A Prayer of Gratitude

O God,
help me to not look upon the morning of this new day
and fail to be grateful.

I am grateful for the rest and renewal of the night,
the freshness of the morning,
the ever-changing pattern of cloud and sky.

I am grateful for
friends who love me and those who reach out and touch my life.
In the praise I give
and the prayers I pray,
let there be the quiet whisper of gratitude in my heart.

With Your gentle spirit,
sweep through my day
and bring forth praise and song from my heart.

Reflection
Day 9

Specifically, what moves you be grateful?

Trying to Let Go

I have come to believe
that if I take something to heart,
it will always be there for me, waiting.
Whether it is a person, a place,
a relationship,
something sacred.
It will always be there,
carrying the same beat of my heart.

When I come to the end of my day
and I try to sleep but cannot,
that is when all of the pathways seem to connect,
and I see the people
I have loved and helped and hurt.
I see
their hands reaching for me.
I hear the beat and see
and understand
what they all mean to me.

It is in those quiet moments at the end of my day,
I know there is no end of the rooms in my heart.

Reflection
Day 9

As you meditate at the end of this day, what do you remember that nudged your soul?

The Gift of Today

As I awaken,
I realize I have been gifted with a new day.
I will begin it by
wildly affirming its beauty.
I will welcome it,
claim it,
care for it,
encourage it,
nurture it.
I choose to be excited,
awed,
and fully alive about
today.
Yesterday is gone.
Tomorrow has not been given.
Today is the gift.
Gracious Lord,
it is enough.
Help me to live it well.

Reflection
Day 10

You have been gifted with this new day. What gift will you bring to it?

The Strain of the Day

O soul,
today is coming to an end,
tomorrow is a long way off.
In the remaining moments of this day,
I seek the fullness of life,
but I need a new hope to receive it.

O soul,
I seek to be saved from lingering in regret,
and to believe that what I am asking for
is ready to be claimed.
Even now,
as I come to the end of this day.

Reflection
Day 10

What gives you hope, especially at the end of your day?

Bonfires

Chapter Two

Anthony went home and immediately started planning his beach event. He spent every waking hour when he was strong enough planning, writing invitations, getting help from his friends who now came over to visit with him because they felt so included in the planning. Occasionally we would FaceTime his meetings about the bonfire event with his friends and family. He kept me informed through every step of the progress, and he expected me to somehow attend. I knew how many like Anthony I was committed to, and he understood that they needed me just as he had.

"Dr. Bill, it's really going to happen! Everyone I've sent an invitation to wants to come! Did you get yours?"

"Yes, Anthony, and I said I'd try to be there via FaceTime."

"Fantastic, Dr. Bill, I'm so excited! This has taken on a life of its own. I have so much hope that this is going to work. Thanks, Dr. Bill, for giving something to hope in."

"Are you ready to teach them the song, Anthony?"

"Me and the family sing it every night before bedtime. I'm ready, and I've printed it out so that everyone will have the words."

The night of the bonfire was a perfect night. Anthony made his "grand entrance" via the lifeguards. All six jeeps in caravan delivered Anthony with cheers and horns. More than sixty people attended, and they were all given an opportunity, if they chose, to share with Anthony and the others how important this event meant to them. I was watching on FaceTime, but Anthony didn't know that I was actually a short distance away observing this wonderful celebration of life.

Then Anthony asked them to turn to the song sheet they had been given. It was time to close the bonfire celebration. Anthony told them that these words were from the book of Ruth, and the words were Ruth's covenant with her mother-in-law, Naomi. He told them that this was now the covenant he and his family had claimed as theirs, and he invited them to be part of their covenant.

As he was about to lead them in song, I began to sing from a distance as I moved toward the circle around the bonfire. He recognized my voice. "Dr. Bill!" and struggled to stand out of his chair. He joined me in singing as we embraced along with his family. We sang the song through and then invited everyone to join us.

"Wherever you go, I shall go. / Wherever you live, so shall I live. / Your people will be my people, / And your God will be my God, too" (sung two to three times).

It was a very sacred moment for all of us. This now ten-year-old boy had transformed us all with a new hope and a new beginning. Anthony would die just months later from an unexpected infection with his family all around his hospital bed. They also fulfilled Anthony's request which was to sing their song after he was gone.

Every year, around the date of his death, many of the people who attended the first bonfire gather at that same place, build a huge bonfire, remember the life of Anthony, and always close with the song that reminds them of their covenant with Anthony and with each other.

When Anthony was told to go home after his medical trials, he felt as if all hope was gone. His life had come to an end. What he discovered was that the only thing that was coming to an end was the trip to California. When he went home to New Jersey, he found a new beginning. He had hope again. He had a reason to fight for every day he could steal from death.

Caring for the Gift

O God,
lest the gift of this day be missed,
and my spirit within be joyless,

I hungrily turn to You
to widen my awareness,
to re-sensitize my response,
to keep alive within me the
gifts You have given.

Grant me eyes that look until I
see.

A spirit that seeks until I
find.

Reflection
Day 11

As you begin this day, what gifts can you give thanks for?

A Prayer for Mercy

O God,
I come to You now
even when my heart
is closed to another.

O Lord,
how foolish is my vanity,
how shameful are my walls of prejudice,
unmoving with my barriers of judgment,
bankrupt with my empty pride.

O patient God,
as I come to the end of a difficult day,
have mercy upon me.

You,
who breathed one breath for all to breathe,
breathe yet again,
and deeper.

Bring me to my soul's awakening
for yet another.

Reflection
Day 11

This prayer asks for mercy. Who in your life could receive your mercy?

I Pause and Pray

O God,
as this new morning begins,
awaken me to new beginnings
and multicolored hopes.

I pause and pray
at the beginning of this day,
lest I walk through the morning
and all its life and loveliness,
with eyes not seeing,
and a heart in which there is no song.

Pull me to my feet
to believe in the best again,
and to sing your praise!

Reflection
Day 12

What are your hopes for this new day?

I Pause and Pray, No. 2

As I come to the end of this day,
I pause to give thanks for its many gifts.
I remember the ways I gifted this day with others.

As this day ends,
I now settle all
the gifts of the night,
as I did the beginning of this day.

Reflection
Day 12

Was there a moment today where you were a gift to someone?

A Prayer for Openness

O God,
be with me as I begin this new day,
lest the loneliness I feel
and the mood I am in
imprison me in self-pity
and limit all that I see and hear.

As I begin this day,
I open myself up to You.
I come before You,
remembering that You are
already here.

And a quiet confidence
comes over me.

Reflection
Day 13

What do you need to open yourself up to today?

Remembering My Creator

O God,

As I come to the end of this day
I humbly kneel before You,
remembering that You did not abandon me.

Come gently into my night and
touch my soul.

As I have brought calm to others this day,
so may I also receive Your calming presence,
and rest knowing there is much that will come
in the day to follow.

Reflection
Day 13

What do you need to welcome into your soul tonight?

Seeking a New Beginning

O God,
who has breathed life into my mind,
and strength into my spirit,
be with me as I look at myself
and seek a new beginning.

Help me
to make peace with the past.
To accept Your grace.
To receive it as well as give it,
And gratefully begin anew.

Reflection
Day 14

What could bring new life to you today?

Seeking a Better Way

O soul,
as I come to the end of this day,
my pessimism is overwhelming me.
It interferes with my hope,
my faith,
my life.

O soul,
before I prepare to sleep,
I will take inventory of my day,
and I will seek God's hand.
I will not succumb to my wrestling thoughts
until I discover a better way.

Reflection
Day 14

What would help you to discover a better way?

On Taking Action

O Lord,
remind me that
I best experience Your love
when caring for others.

Now,
as I enter this
never before lived day,
remind me that
love is not
something You call me to feel
but something You call me to do.

Reflection
Day 15

How might you practice love today?

A Teachable Moment

I come to the end of this day and
I am coming to learn and realize
some vital elements for my life.

I am coming to learn
that the only thing really eternal about me
is the communion I have with others.

I am coming to learn
that the only thing I will take beyond this life
will be what I share with others.

It is then I realize how to decide
between what I think is so urgent
and what is really important.

It is then I realize why I can
commit to someone who is in despair.
That with confidence, take hold of them,
and assure them they no longer face their fears alone.

As I let go of this day,
I will embrace these teachable moments
and begin tomorrow with a renewed purpose.

Reflection
Day 15

What are those important things that you can affirm at the end of this day?

Hope Restored

Chapter One

The beginning of this story takes place in a children's cancer ward. One particular room had two children. One was just a young child, who was in constant pain with a mother who rarely came to the hospital. He was also not expected to live more than just a few weeks due to a malignant tumor in his brain.

The other patient in the room was a sixteen-year-old boy diagnosed with cancer and who had just had surgery to amputate his left leg. Needless to say, he was in deep depression, and no one had been able to get him to talk about the surgery or anything else for that matter.

He had shut himself off from the rest of the world. Even his mother couldn't reach him. He became my next patient.

I sat down beside his bed and introduced myself. "Paul, my name is Bill Stephenson, and I'm a counselor. I work only with kids like you who are facing a life-threatening illness. I know I can help you get through this, but only if you want to get through this. At least think about it, and I'll check in on you tomorrow. Okay?"

Paul just looked up at the ceiling with no emotion shown. I got up and met his mom standing in the hallway.

"Dr. Stephenson, I am at my wits' end. He won't even speak to me, and he knows how hurt I am."

"He's here for a while," I said. "Let's see if we can pull him out of his shell."

Later that day, all the children in the ward (except infants) were to go to the recreation room to welcome Santa Claus, and I was to tell or read a story. Paul was also there in a wheelchair. I sat down on the area rug with all the children around me. As I was reading a story to the children, I noticed how much Paul was attentive. He wasn't in some other world. He was present the entire time.

Later that evening, his mother and I sat in his room, talking, but often distracted with the constant crying of the young child, whose mother had not been there the entire day. Finally, Paul's mother couldn't take it any longer. She burst out of her chair, went over to the young boy, and picked him up, walked over to Paul's bedside, and said, "*Here*, Paul, you're not doing anything except feeling sorry for yourself. Hold the boy and help him to calm down."

She placed the child in Paul's arms and stomped out of the room. I watched Paul and the young child for several minutes. He was so tender and caring. He looked at me, and I could see a little smile beginning to unfold. The little boy stopped crying.

To be continued after Day Twenty

Seeing God Through Others

O God,
this is the day that You have made.
As I begin it,
I center myself in You.

Come to me and calm me.
Expand my awareness,
sensitize my responses,
keep alive within me a spirit
that has room enough
for the unplanned
and the unscheduled.

Today, help me see You
in the eyes of others
and hear You in their voices.

Reflection
Day 16

How might you stay open to the unplanned and unscheduled?

A Prayer for Serenity

O God,
as I come to the end of this day,
I center myself in You.

I seek
Your gift of calm and serenity.
Your whisper of
"Be still and know."

O God,
as I come to the end of this day,
help me to overcome
the feelings of being hurried and harried.
Let me know Your peace for my soul
and to gift back to You this day.

Reflection
Day 16

What distractions do you need to let go of that will prepare you to receive this serenity?

A Prayer to Discipleship

As this new day begins,
I hunger for the breath of God,
in my mind,
and the soul of God,
in my spirit.

As this day begins,
I will keep from hugging my fears
and nourishing my doubts,
as well as frustration with those
I encounter in this new day.

O Eternal Source of my being,
grant me to carry to others
the kindness I look for,
the gentleness that the world seeks,
and be courageously loving
to whomever I encounter.

Reflection
Day 17

What is the deepest hunger in your soul that needs to be heard and listened to?

A Prayer of Grief

As I come to the end of this day,
I need my soul to kiss me again
and whisper in my heart
the claim that life has upon me.

As I come to the end of this day,
teach me, O soul,
how to face the ones waiting for me,
here and now and close at hand.

As I come to the end of this day,
I pray my soul will calm
so I can reach for the joy
as it flies.

Reflection
Day 17

As you review your day and calm your soul, how do you imagine receiving joy?

Graciously Gifted

O God,
today is Your gift to me.
What I do with this day
is my gift back to You.

Let
no ungenerous thought be in my mind today,
no intent that is hurtful to another,
no purpose that has harm in it.

To each person I meet,
let me be
quick to speak a grateful word,
ready to hear what is being said,
eager to believe the best
and forgive the worst.

Touch me with the sweet simplicity of this fresh new day,
and may gentleness and
kindness fill my heart.

Reflection
Day 18

How will you keep mindful of your grace and love of God as you meet each person today?

A Prayer of Humility

I struggle
with my image of God:
Mercy or Justice?

Then Jesus says,
"You cannot receive
what you will not give."

As I come to the end of this day,
I humbly bow
with a lump in my throat,
with pain and disappointment over a
recent hard experience.

In my head,
I know that I will be
free to give to others
when I accept God's love and care.

O soul,
what am I waiting for?

Reflection

Day 18

What disappointment do you need to acknowledge so that
you can better receive the gifts of a day ending?

Tasks I Must Do

O God,
who has given me powers I seldom use,
and opportunities I often ignore,
let this be a day of a new
beginning.

O God,
remind me that Your will for me
is not that I give up
but that I grow up.

I will not
lose my fears until
I face the things for which I am afraid.
Nor can I find a faith to live by
until I begin to really live by faith.

Teach me
of the next step.
That prayer is never the fulfillment,
but rather the soul's encouragement
to begin again.

Reflection
Day 19

What fears do you need to face that will keep you from celebrating this day?

Centering to Let Go

Today was one of those days
when everything seemed to go dead wrong.
I made so many mistakes
that I wondered if I was a mistake.

Today, I was suffering from the fatigue of fate
and from hardening of my categories.
I felt betrayed by my hope.

Today has come to an end.
I will take some time to center myself,
to remind myself that I am not stuck,
that my vote against me is short-term.

As I come to the end of this day,
I remind myself that the life-long conclusion
is that God's vote is for me.

Not just for now
but for always.

Reflection
Day 19

Journal on a day that could fit this prayer/poem.

A Prayer for Openness, No. 2

As I begin a new day,
my soul waits for my Source
to come gently into my life again,
like the fading of dark and daybreak.

As I begin a new day,
I yearn to be awakened
to all the resources in my life,
lest I measure my hope
by the mood of the moment
and miss what this new day
has in store for me.

As I begin a new day,
I now open myself to this gentleness,
reminding myself that this Source
is already within me,
pulsating.

As I begin a new day,
let me accept this gentle
strength so that I can have
the wisdom
to share.

Reflection
Day 20

What would it be like to open the door to this new day? What does it reveal?

The Gift of Creation

O God,
the Source of all sound,
the Voice that speaks in my quietness,
the Presence that fills my emptiness,
the Mystery that encompasses all meaning,
the Meaning that penetrates all mystery.

You are my God.
I am Your precious child.
You know me by name,
You love me with Your grace.

As I come to the end of this day,
let me now be still
and know Your calm
and Your grace.

Reflection
Day 20

Read this prayer poem again out loud, then journal about the
silence you just experienced following your reading.

Hope Restored:

Chapter Two

I returned the little boy to his crib, and Paul began to talk for the first time.

"I had been invited by a girl in my junior class to be her date to the annual spring formal. After my surgery, she sent me an e-mail saying that she had changed her mind and I would understand," he said bitterly. "I understood. I mean who would want to go to the annual formal with a cripple? I feel like I don't belong anywhere. Except tonight. Tonight I felt like this is the only place where I feel like I belong."

"Paul, you have gone through a tremendous ordeal, and I think you know that there is probably more to come. Your cancer is a tough one. It stands to reason that here you feel safe, and that's why a lot of the kids here consider this a part of their home because here their friends know what they're going through, and they want to support them like they get support."

"You know, Paul, you will be getting well enough to go home soon. Have you thought about what you want to do when you go home?"

"Tonight got me thinking. When Mom gave me the baby to hold and he quieted down and watching you read stories, I could do that. Could I come back and volunteer here and read books to the children? Maybe I could help some teenager get past the shock of the word *cancer*, which I remember was like a kick in the stomach. Maybe I can help out around here. Or am I too young to volunteer?"

"I think you may have hit on something that a number of us have talked about. Peer support groups and teams. You would need to go through some training, but, Paul, yeah, I think you would be a terrific volunteer. Let me make some calls and see if we can get it arranged."

"Thanks, Dr. Bill. That's what most of the kids here call you. Is that okay?"

"Paul, I'm just glad you are talking again. I think you're on your way back from under that dark cloud."

"Dr. Bill, you gave me a reason to want to live again. You gave me back my hope."

Paul would get the training, and he came back to be the best reader you could ask for. He always found a way to turn each story into an adventure. When he came to volunteer, every kid was out of their bed and following him around or waiting in the recreation room for him to come and read to them.

Six months would pass, and Paul's condition worsened rapidly, and an infection would be his downfall. When he entered the children's ward for the last time, he was in great pain, weak and unable to get out of bed, except kids kept sneaking into his room, asking him if he would read to them. He read to them until he could no longer. A divine hope descended upon him, and he was gone.

Paul thought that his life was at an end when they amputated his leg. In a sense, it did come to an end, but he found a new life, a new beginning, and he came to live it passionately to the very end.

A Reminder

O God,
remind me of the gift of this morning
which wakens me to new beginnings,
stirs within me a new hope,
nudges my soul to believe again.

Surprise me with the wonder of this new day…
that I need not drag into it
the disappointments of yesterday.

For You are the one who brings
new life out of all my
crying and sighing,
hoping and believing,
and recreates me ever fresh
through Your promise in Jesus.

Reflection
Day 21

Where in your life do you hunger for renewal?
What part of your life needs to die so that it can be reborn?

The Illusion of Saving

I spent today
obsessed with saving
and very little time risking.

I spent today saving
little disappointments,
and brooded defeats,
and very little time at the cross.

I spent today saving
the torn shreds of my petty purposes
and very little time
advocating for so many who suffer.

Lord,
as I come to the end of this day,
teach me again how to be saved.
Teach me again
Your amazing secret
why even the caged bird still sings.

Reflection
Day 21

Lately, time has subtly become our adversary.
What can you say to yourself or pray to God how you want to turn that around?

A Road Less Traveled

Good morning, God.
You have ushered creation
into this new day.
It feels fresh and untouched.
Even the sun has yet to give its warmth and color.

Lord, in this prayer,
I ask for the same miracle:
To begin this day renewed
and refreshed and untouched.
Expectantly, I await the warmth and color
my relationships will give to me as I give to them.

Lord, You lay a path before me.
It's a new one,
not like the one I traveled yesterday.
I can't make it on my own.
My balance is unfavoring.

Lord,
Take my hand and hold on to me
as I go through this day.
Hold me close, Lord,
so that I always know I
never walk alone.

Reflection
Day 22

As you begin your day, what would you ask God?
Now ask if it is something you already have.

A Prayer for Trust

As I come to the end of this day,
I feel as if my trust has been
taken out of my spirit.

What happens to my soul
when I am controlled by suspicion
and guided by mistrust?

What happens to my relationships
when I become so concerned
about what people might take
from me
I never understand what they are trying
to give to me?

As I come to the end of this day,
I want to build walls around me
to protect me from being hurt,
but they also keep people from loving me.

Thus, the conundrum.
Is trust a gift or a reward?
I am learning that trust, earned, is trust counterfeit.

Trust is a gift that calls me to reach deep into my being
and offer myself as a gift from my soul.
A gift I hold as only from God.

Remembering this now allows me to let go of this day.

Reflection
Day 22

As your day comes to an end, what is it that you keep holding onto? What do you need to let go of at this day's ending so that rest and renewal will come?

Where God Can Be Found

O Lord of my life,
grant me in this new day
the sensitivity to see You looking at me
through the eyes of those who love me,
through the lives of those who disagree with me,
through the struggles of the problems
I choose to confront me.

O God,
I know not what this new day may bring
but help me to bring to this new day inward
eyes to see You and sense Your presence
as You continue to create this awe-inspiring universe
and continue the creation of me and my soul-making.

Gracious Lord,
as the sun brings color to my world around me,
I give You my praise and
glory in the spirit of Jesus.

Reflection
Day 23

What gifts that God gives you for this day are especially helpful?
What gifts will you yourself bring to this new beginning?

A Prayer When We Are Lost

As I come to the end of this day,
I find myself recalling
every raised eyebrow,
every embarrassing moment,
every slight,
every letdown,
every put-down.

As I come to the end of this day,
I get tangled up in guilt and shame.
I get smothered by my success.
I get choked on sobs nobody cares.

I need to heal this memory.
I need to dwell on how I have been helped today
and not how I have been hurt.

As I come to the end of this day,
I must heal myself of hurts and grudges,
disappointments and betrayals.

O God,
I hope You will find me
and whisper to let go
of today and then risk
trying again tomorrow.

Reflection
Day 23

Coming to the end of a day that is filled with regrets, mistakes, and
unfinished businesses will keep anyone from sleeping.
Journal what those issues are and then journal the strengths
you own to balance any self-criticism.

Whisper

I look upon this new day,
greeting it with all its anticipation,
and I am grateful for being alive.
Thankful to have a Creator to share it,

I whisper your name.

I feel rested and renewed,
and the day is still early,
quiet and fresh.
I look up and the clouds and sky
compete for space above me,
and again,

I whisper your name.

I stand outside in this new day,
and I remember those
who have touched my life.
I know that You are the one
I thank for them.
And so,

I whisper your name.

My life is filled with praise.
You sweep me up in Your arms.
My spirit wants to sing.
I turn and…

You whisper my name.

Reflection
Day 24

In your quiet time, listen to the whisper in your ear, "I am here."

A Time to Be Quiet

O God,
as I come to the end of this day,
help me to find quiet for my soul.

I need quiet now
all around me,
lest I add to the noise of the world
that never seems to die down.

I end this day
in Your quiet presence.

Reflection
Day 24

In your quiet prayer time, say the following, "Be still, and know I am here."
Then meditate and journal on these words.

Measuring My Life

O God,
who has given me grace I seldom claim
and strength I often fail to affirm,
let this new day be a new beginning.

Let me not brood today
over what I don't have,
lest I miss all the gifts
I have already been given.

Resensitize Your hope for my life,
lest measuring myself
by the worst I have done,
I fail to believe in
what You know I can become.

Remind me today
that You are within me to save me,
helping me to make peace with my past,
wanting me once again to accept Your grace,
to receive as well as give it,
and gratefully begin again.
And again.

Reflection
Day 25

What do you need to do or say that will truly make this a new beginning for you?

As I Receive, So Let Me Give

O God,
who wanted and willed me into this life,
so often I come to You
with needs to be met.
So seldom do I come with joy
for what I have already received.

As I come to the end of this day,
resensitize me to the gifts I received,
to the silent ministries of Your quiet gifts,
to the rest and renewal of this night,
to the freshness and feeling that comes tomorrow,
to the touch and trust of a friend,
to the forgiveness and smile of a child.

As the living of this day ends, it comes
with memories of having been loved,
with actions of goodwill and caring,
with openness to change, and tomorrow,
with the quiet and confidence of faith.

Eternal Love,
within whom I live,
as I receive,
so let me give.

Reflection
Day 25

What are you thankful for as your day comes to an end?

Listening to My Heart

I fish. There's something about fishing that gives me calm and connection. I fish on a pier in San Diego that spans more than six hundred feet out over the Pacific Ocean. On any given day, there will be more than thirty others who will be throwing their line over the side. We get to know each other, those of us who are regulars. But mixed into our lot will be some people who are homeless and the resident walkers, and also many tourists will take the long walk out to the end of the pier.

In the middle of the pier is a café with fantastic breakfast burritos. I fish here because I also get to observe people, all coming with different agendas. It's also a place where some will come and walk to the end but not come back. The riptide is so severe at the end of the pier that if you jump off from there, you won't come back to the surface. This is the story of one of them. Her name was Amy.

Early one morning, I was standing at the entrance to the pier, talking with some fellow fishermen, and we were all about to walk out farther along the pier to our favorite places to fish, but I noticed a well-dressed young lady about to go on the pier. Too well dressed for such an occasion as not to be noticed.

As she was about to pass me, I said, "Good morning. How's it going for you today?"

She stopped and looked at me for what seemed a very long moment, and then she said something with no emotion at all, "I'm going to walk to the end of the pier, but I'm not coming back."

I immediately knew that my fishing for that day was not going to happen. I walked closer to her so that I could talk to her in a calm voice. "As you are walking on the pier, may I walk with you? There's a café in the middle of the pier, and they make great coffee. Can I buy you a cup? And as we walk, would you tell me about yourself? My name is Bill, and I'm a counseling psychologist. I sense that you are in a lot of hurt right now, and I want you to tell me about it."

"My name is Amy, and I'm from Phoenix. I came up here because I was promised a job, and some girls I had known in college said that I could live with them and share the apartment. But when I got here, there was no job, and these girls had given the space in the apartment to someone else, and then someone broke into my car and stole all my stuff, including my phone and computer. I am so devastated that all I want to do is die, and that's why I'm here, and that's what I'm going to go and do!"

We continued to walk together in silence, and as we neared the café, I said to Amy, "Your day is worse than you thought. Not only did you not get the job or have a place to live, but you're also not going to jump off this pier. Today you will not kill yourself."

She remained unresponsive. I got her a cup of coffee, and we continued our walk to the end of the pier as the sun began to peek over the horizon. We stopped to look at the sun rise, overlooking the eastern rails of the pier. In the water were dozens of surfers and on the pier were the many fishermen throwing their lines into the sea.

"Amy, do you see all these people in and around this pier? This is their pier. It's a very important part of their life. How do you think they will feel if you tried to kill yourself from their pier?"

"I don't think they would care. They don't know me. Why should they care?"

"They may not know you personally, but to watch another human being suddenly die is going to have a major emotional effect on them. Many will wish they hadn't been here today. Some may not want to come back. Others will grieve because they witnessed your death. No, Amy, your death will have quite an impact upon them. Not to mention your family and friends. Can you imagine how they will feel? How do I tell your parents?"

With tears in her eyes, she spoke, trying to catch her breath at the same time, "I just don't know what to do, where to go, who to turn to! I feel so alone!"

"Amy, I want you to do something for me. Actually, I want you to do something for yourself. Right now, you're thinking and making decisions from out of your head. Take a moment and just breathe. And then, I want you to ask yourself, 'What does my heart say about all this? What is my heart saying to me right now?'"

She took a moment, and then she fell into my arms and just sobbed. Several minutes later, I escorted her to the café to use the bathroom and sit and continue our conversation.

"I'm not going to hurt myself any longer, Dr. Stephenson."

"Amy, I prepared for you what I call a safe contract. If you begin to feel suicidal, I want you to look at this and remember you telling me that you were safe and wouldn't self-harm. And here is a list of places to help you get home. Here is my phone, and I want you to call someone back home to tell them you are on your way back."

She did as I asked and then signed the safe contract as I had. I walked her to the entrance way to the pier, gave her a hug, and wished her well. She also had my card and knew she could call anytime.

As she neared her car, she turned to me, placed her hand over her heart, and mouthed so I could understand, "I'm listening to my heart." She turned, got in her car, and drove away.

She would become the fourth person I would stop from suiciding off the Ocean Beach Pier.

Amy had come to believe that "ending it all" would be doing everyone else a favor, and she would no longer have to face the grim struggle of beginning again. But she was able to let go of all the failures she had recently endured, and with just a readjustment of her framework, she was able to choose to create a new beginning.

A Psalm of Joy

As I begin this day,
I am awakened to my soul,
and I am grateful for the
common,
familiar,
miraculous.

For the good earth beneath my feet.
For the stately clouds above my head.
For the beauty of memories nestled in my heart.

As I begin this day,
I awaken my soul,
for all frightened lives, boldly lived.
for handicapped lives, courageously lived.
for all shortened lives, faithfully lived.

As I begin this day,
I awaken my soul,
lest I forget that from day-to-day
and moment to moment,
my life has been blessed,
and my experience enriched
by those who have gone on before me.

As I begin this day,
my soul is awake
so that I don't become obsessed
with what I lack,
lest I rob my soul of joy
for all I have.

Reflection
Day 26

What blessings do you have right now that can help awaken your soul?

A Prayer for Wisdom

O God,
as I come to the end of this day,
help me to let go of hugging my hurts.
Release me from finding blame.

As the daylight begins to fade,
challenge me to remember all the hope
and encouragement I received.

I open myself to You
and the rest and renewal You gift to me.

As I come to the end of this day,
I am strengthened by the wisdom
and presence You give to my life.

Reflection
Day 26

As this prayer poem suggests, can you recall when you
felt encouragement by God's presence?

I Am a Child of God

As I breathe in the cool freshness of this day,
I yearn to be like a child again.
To be held against the breast of God,
who quiets my fears
and encourages my faith to begin again.

Today,
I will embrace this great and gracious Mystery,
who parents me through this mysterious plan of my life,
who created me in His image,
revealed His likeness,
my likeness…

As I begin this new day in my life,
I ask for the wild courage
to be a child of God again
and seek to become what I have now dared to claim.

Reflection
Day 27

Describe what it would be like to be a child again.
How will you apply that attitude into your day?

Wounded But Not Dead

As I come to the end of this day,
it seems like it won't end.
I ruminate over its stressful events.

I need
to make this day stop.
I need
to check my address and
to know who and whose I am.

It is when my days make me feel
frayed, frazzled, and frightened,
and I am hurting, hassled, and hungry
for peace.

I need to remind myself
I have a gift already within me,
waiting to be rediscovered.

As I come to the end of this day,
I am wounded,
but I will recover.

Reflection
Day 27

What gifts that God has placed in you that will help you end this day?

Truth

O God,
as I begin this new day,
grant me the courage
to accept the truth about myself.

Even if it is
beautiful!

Reflection
Day 28

Take a few moments and share in your prayer and journal some
of the gifts God has put into your life for today.

Confessing My Pride

O soul,
As this day comes to an end,
I take inventory of this God-given day, and
I recall the many times I transgressed
and played the fool of someone who is superior.

Free my spirit of this grand illusion
and bathe my heart of its foolish pride.

Reflection
Day 28

In your significant relationships, how can you be less controlling and more compassionate?

A Prayer for the Moment

O God,
You have given me
bread and to spare.

I ask for friends,
and You give me a community.

I ask for love and meaning,
and You give me Christ.

As I begin this day,
make me sensitive to all these blessings,
sensitive enough to be grateful,
grateful enough to be humble.
humble enough to be useful.

Reflection
Day 29

Take a moment and write a prayer of thanksgiving.

Living in the Moment

O Lord of my life,
As this day comes to an end,
I recall seeing You through the lives
of those who come to me with a
disease that's life-threatening.

They are teaching the teacher as I struggle with
the many losses I am experiencing.
They are teaching me not to let anticipation
be my barometer for the living of each day.
"Live in the moment,
and there you will find strength."

O God,
help me to bring this day to an end
and sense Your presence in my life
as You nourish my soul.

Gracious Lord,
as the sun sets and colors my world around me,
I give You praise and glory.

Reflection
Day 29

Take a moment and offer up in your meditation time
those persons who give life to your soul.

My Stubborn Faith

I want to begin this day wildly affirming
this bent toward
beauty and gladly
choosing
this trend toward transformation.

I want to welcome it,
claim it,
trust it,
encourage it,
bet my life on it.

And by my stubborn faith in its working,
release it in greater measure within me.

That I too may be transformed.

Reflection
Day 30

What action do you need to implement in order to move toward your own transformation?

A Teachable Moment, No. 2

As I come to the end of this day,
I am weary of battles within.
The good in me versus the bad in me.
The best of me versus the worst of me.
The cowardly versus the brave in me.
The kindliness versus the meanness in me.

Because of my hypocrisy,
I feel exposed, shame, and resentment.
It is then that my hypocrisy surfaces,
and I must tell myself the truth
and discover the value of
living a congruent life.

I am coming to learn
that for me to be in genuine recovery,
I must tell myself the truth more consistently.

Then, perhaps,
sleep will
come.

Reflection
Day 30

Journal to your soul and describe the hypocrisy you carry with you each day.

An Epilogue Poem:

Sunsets

There is a need for an ending
so that we will have the courage
to go on with the present.

There is a need for an ending
so that we will have hope
for the future.

There is a need for an ending
so that what we hope
for ourselves and for our loved ones
is going to be vindicated.

There is a need for an ending
so that we know that which is
good but seems in peril now
will survive.
And what is incomplete now
is going to be fulfilled then.

Every journey,
every day,
every book
has an ending.

And then,
hopefully,
comes a new beginning.

Reflections

Acknowledgments

Many of these prayer poems were inspired by the clients I was asked to assist as they came to the end of life. I would urge them to journal their thoughts and feelings, and together we would develop a prayer poem that reflected their experience, and I will always be grateful for their contribution to my life and profession. They are the ones who taught me the value of beginnings and endings. I've been blessed to have this "great cloud of witnesses" surrounding me with both encouragement and inspiration.

Another significant group has been the Water's Edge congregation in San Diego. They have been my audience for all of my writings and have invited me again and again to share these notes from my soul. They would listen and give me their thoughts and impressions, a cheering section throughout the journey. I would especially like to thank the pastors—Molly Vetter, Elbert Kim, and Jessica Strysko—for allowing me to share my writings as a part of worship.

Some from Water's Edge agreed to be not only readers of the manuscript but contributors. Richard Smith was instrumental in developing the responses for journaling throughout the book which challenged me to rewrite some passages in order to clarify the message. I can't thank him enough for critiquing my work with a caring spirit.

And where would I have been without the Thursday Men's Club? For more than two decades, this ecumenical group of mostly old surfers has been meeting each Thursday at 6:00 a.m. for Bible study and prayer. A year ago, they asked if I would start the weekly meeting with a morning prayer about new beginnings. Their comments and suggestions were instrumental in shaping this book of devotions.

One of the members of this group, Rick Morris, volunteered to take the manuscript and format it into a book. His previous experience in book publishing enabled me to put the prayer poems in such a way as to challenge the reader to use the book for their own personal devotions. He was also my biggest critic and corrector. I am so deeply grateful for his love and friendship.

I am also thankful to all the readers of my previous three books and the many comments I received from them. Their comments inspired me to write a very different kind of book this time; one that, in essence, is more devotional.

And lastly, I have been blessed to have as my biggest and most constant encourager, my wife. Carol has always been the first to read anything I write, and she was most helpful in deciding which of the many prayer poems would make into the book. I am thankful for her patience as I sat in my home office, alone for hours at a time, preparing this book.

It is with love and affection that I dedicate this book to her.

About the Author

In his private practice, Dr. Stephenson counseled more than four hundred children, youth, and adults who had been diagnosed with a life-threatening illness. This counseling would also require grief care to their family members and, at times, the community. He has assisted in the care of two communities who experienced major losses to violence. He has participated in the development of hospices in San Diego, Seattle, Denver, and Chicago areas. His training includes developing a "death ward" in a hospital in Tijuana, Mexico, as well as developing a team of caregivers to provide end-of-life care to young people. He remains active in providing workshops to staff who work with children coming to the end of life, as well as consulting for other professionals who have clients in this condition or for parents struggling with what to do.

He is an active layman and teaches an Adult Sunday school class in one of the largest United Methodist Churches in California. Most of the curriculum used is written by him. It is written in a style that promotes conversation about the human condition and how our faith addresses such issues as loss, resentment, betrayal, disappointment and defeat, to name just a few.

Dr. Stephenson has written three previous books, two of them related to his work with the terminally ill. He is currently writing his next book on rediscovering hope as he describes how persons in his care at the end of life found a hope they could believe, live, and let go with dignity and power.

CPSIA information can be obtained
at www.ICGtesting.com
Printed in the USA
FSHW021318211120
76057FS